ABANDONED
LONG ISLAND

RICHARD PANCHYK

AMERICA
THROUGH TIME®
ADDING COLOR TO AMERICAN HISTORY

America Through Time is an imprint of Fonthill Media LLC
www.through-time.com
office@through-time.com

Published by Arcadia Publishing by arrangement with Fonthill Media LLC
For all general information, please contact Arcadia Publishing:
Telephone: 843-853-2070
Fax: 843-853-0044
E-mail: sales@arcadiapublishing.com
For customer service and orders:
Toll-Free 1-888-313-2665

www.arcadiapublishing.com

First published 2019

Copyright © Richard Panchyk 2019

ISBN 978-1-63499-128-5

Typeset in Trade Gothic 10pt on 15pt
Printed and bound in England

CONTENTS

ACKNOWLEDGMENTS

T hanks to Lizzie and Matt for their company on some fun abandoned adventures. Thanks also to Alan Sutton and Kena Longabaugh for their continued support and guidance.

All photos are by the author, except for the images on the bottom of page 8, the top of page 10, and the bottom of page 13 [courtesy of the Library of Congress].

INTRODUCTION

Why do abandoned buildings exist on Long Island, or anywhere for that matter? The simple answer is that it is often cheaper to leave them there, long after they have served their useful purpose, than to demolish or replace them. The word "abandoned" is its own explanation; the occupants up and left, unable or unwilling to use or even think about the space any longer. In some cases, these abandoned structures sit on public land owned by the federal, state, or local government, so spending money to repair them or remove them would come at taxpayer expense from already tight budgets. As for privately owned abandoned buildings, they are either unwanted and neglected by their owners for various reasons, or they await a buyer—or perhaps the land has been purchased and a redevelopment awaits local approvals and financing.

Abandoned places are both historic moments frozen in time, and constantly deteriorating and devolving sites. All of them await one fate or another—whether it is a never-ending descent into decrepitude, complete demolition, or perhaps even a miraculous restoration. With abandoned buildings, anything is possible. When I revisited one site that two years earlier had been the ruin of an elegant old estate outbuilding on the southern perimeter of the SUNY Old Westbury campus, hoping to take more photographs, I was both pleased and disappointed (and a little surprised) to find workers busy repairing and restoring the place. When I went in search of an old tuberculosis hospital complex in Plainview, I arrived (just a few months too late; the most recent Google aerial still showed the old buildings in place) to find it had been demolished and a massive condominium development erected in its place.

Many of Long Island's remaining abandoned places are even more interesting in their stark contrast to adjacent homes, parks, and stores. The photographs in this book are ephemeral, transient images of ever-changing places. They represent the

uneasy and eerie commingling of remnants of the past with the present and future. They are abandoned, yet in many cases they are frequented by adventurers and artists who leave their marks and alter the places, further adding to their aesthetic appeal and mystique.

I hope that you will enjoy perusing this book as much as I enjoyed assembling it.

WARNING: Abandoned places can be treacherous and are best enjoyed safely within the pages of this book!

1

ROSLYN GRIST MILL

Abandoned places aren't always off the beaten path. Sometimes they are hidden in plain sight, right in the heart of downtown, as is the case with the Roslyn Grist Mill. The Robeson-William Grist Mill was built *circa* 1715-1740 on what is now Old Northern Boulevard, the Village of Roslyn's main drag. Once water powered by a channel leading to Hempstead Harbor, the mill is one of a few remaining examples of Dutch commercial (i.e., non-residential) architecture left in the country. The mill was active all the way until 1916, when its owner gave it up and the village took over and restored it. In 1919, it was converted into part museum, part tea house, run by Alice Titus. The Roslyn Grist Mill Tea House entertained thousands of customers over the years until it closed in 1975, after which point Nassau County purchased the building. It has remained empty since then, abandoned and left to decay, and entertaining mainly to the pigeons who frequent its roof. Over the years, there has been much talk about restoring the mill. In the summer of 2018, $440,000 in grant money was announced and with it the promise to renovate and rejuvenate the old building. Time will tell if this ancient structure will return to life in a meaningful and educational way as has been the intention for many years, but as of October 2018, the building presented a startlingly crumbling appearance, a mere shadow of what it once used to be. Thankfully, much of the original wooden structure was sheathed in a protective shell back in the 1970s, making successful restoration more likely.

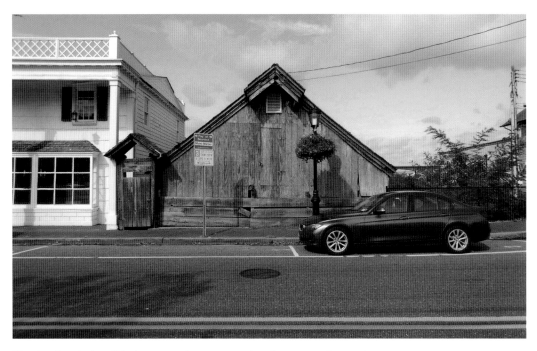

The abandoned grist mill looks unassuming, yet mysterious from across the street.

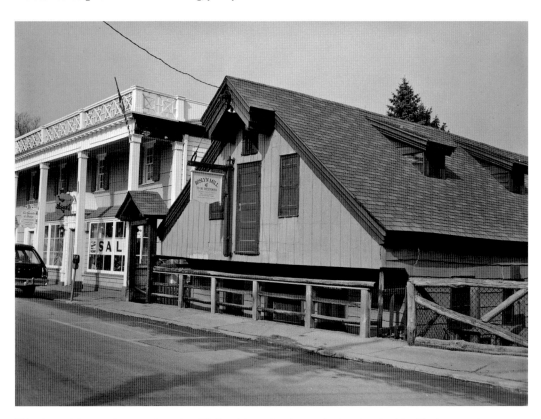

This photo of the exterior was taken *circa* 1976, not long after the newly abandoned grist mill's days as a tea house ended. Note the sign that says the mill will be restored—forty years later it still awaited those repairs.

The full size of the grist mill building is only evident from behind.

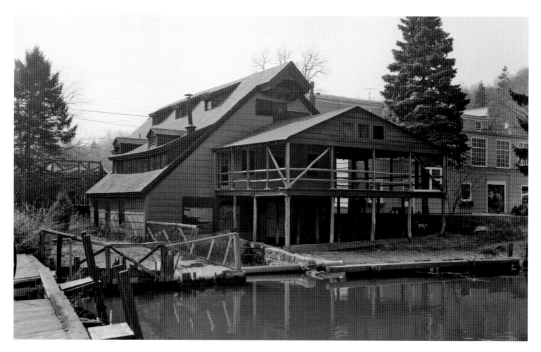

As of 1976, the rear of the building had an extension.

This used to be the entrance to the tea room, through here and down the stairs.

What looks like a rusty iron "key" protruding from the front of the building was actually a brace to hold the signpost that used to adorn the facade.

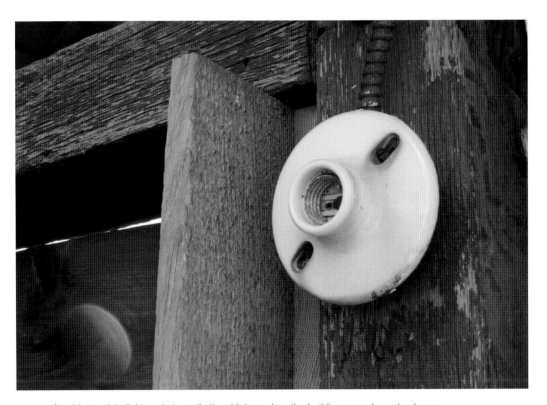

An old porcelain light socket recalls the old days when the building served as a tea house.

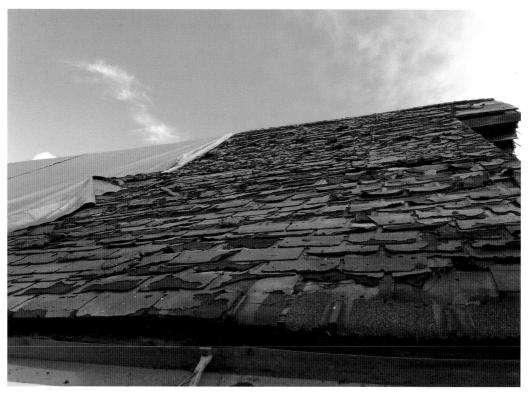

The roof is covered in multiple layers of shingles, all of them deteriorated.

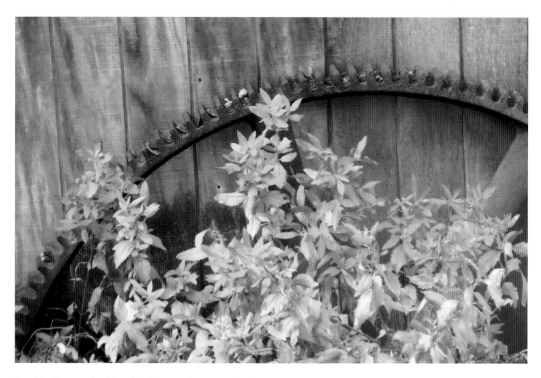

An old mill gear wheel is still evident on the east side of the mill.

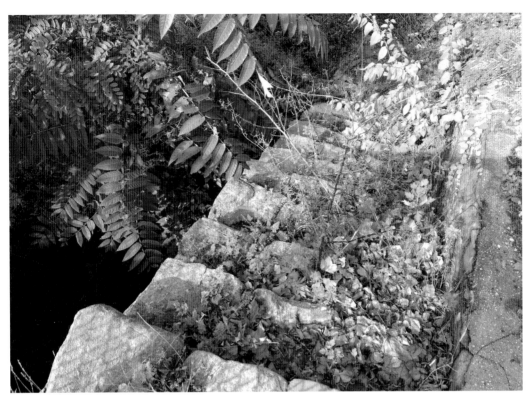

Stone steps alongside the grist mill now just lead down to weeds and marshy land.

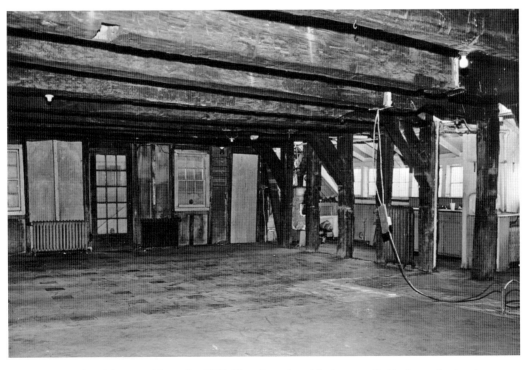

The interior of the second floor *circa* 1976. There is no sign of the tea room that had recently closed.

2

THE CENTRAL RAILROAD OF LONG ISLAND

(AKA Central Branch of the LIRR and Garden City-Mitchel Field Secondary Branch of the LIRR)

The Long Island Rail Road (LIRR) was one of the first American passenger railroads; the tracks reached as far east as Hicksville by 1837. By 1844, there was service to Greenport on the "main" line, which ran through central Long Island. As time passed, more track was laid and many more new stations were opened. But changing demographics have caused almost fifty LIRR stations to be closed over the years, as well as entire branches. The Rockaway Beach Line, which ran through Queens from Rego Park to the Rockaways, was abandoned in 1962. Another abandoned line is a part of what was formerly the Central Railroad of Long Island, later operated by the LIRR, which ran from Garden City to Bethpage in Nassau County. This abandoned stretch of tracks is a direct descendant of the vintage 1870s Central Railroad of Long Island, created by Garden City founder A. T. Stewart and soon after taken over by the LIRR.

Stewart used the railroad line to transport bricks from his brickworks in Bethpage west to the Hempstead Plains, to build his newly conceived community called Garden City. Stations on the Central Branch included Meadowbrook (opened 1873), which served the Meadow Brook Club for activities including fox hunts, golf, and polo matches; and Mitchel Field (opened as Camp Black Station in 1896), which transported people to and from the bustling air base. Most passenger service on what was once the Central Railroad ended in 1939, but a shuttle service ran for a few stops between Country Life Press (in Garden City, opened in 1911) and Mitchel Field until 1953. Other stops on the defunct rail line included one for Long Island's newspaper, *Newsday* (1949-1953) and one for the A&P supermarket (1928-1953).

The Central Railroad's remnants are the best preserved and most easily accessible abandoned tracks on Long Island, in part because for decades they were still used once a year for the circus train going to the Nassau Coliseum, and for occasional LIRR maintenance trains. The remaining tracks run east-west between Franklin Avenue in Garden City and E Road in East Garden City, for a distance of about two miles. A walk alongside the tracks reveals all kinds of train-related debris, including pieces of coal, rail spikes, wooden tie fragments, and other vintage bits and pieces. The last trace of the tracks is in a parking lot just off Endo Boulevard, where they end abruptly in what is often a large puddle of water if it has rained anytime in the past few days. It's an eerie feeling standing there knowing trains once ran straight through, continuing on across what is now Eisenhower Park and all the way to Bethpage.

What else remains of this former railroad line? An abandoned, ivy-covered Central Branch railroad trestle lies hidden in the wasteland of woods and brush between the Meadowbrook Parkway and the northbound entrance ramp from Stewart Avenue. Even though I knew it was there, it was impossibly hard to find and I almost gave up. There's also the former Clinton Road Station at the intersection of Clinton Road and St. James Street North in Garden City (which is very easy to find, and very cool to behold). It was built in about 1911, and after it closed in 1953, it was repurposed as Station #3 by the Garden City Fire Department. Aside from the main tracks, there are also several still-visible rail spurs off this defunct rail line that led to Mitchel Field warehouses.

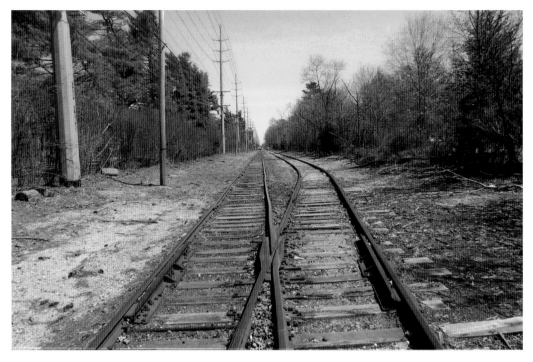

The abandoned Central Railroad of the LI splits from the Hempstead Branch at Franklin Avenue, carrying a single track for about 1,500 feet until they become two tracks.

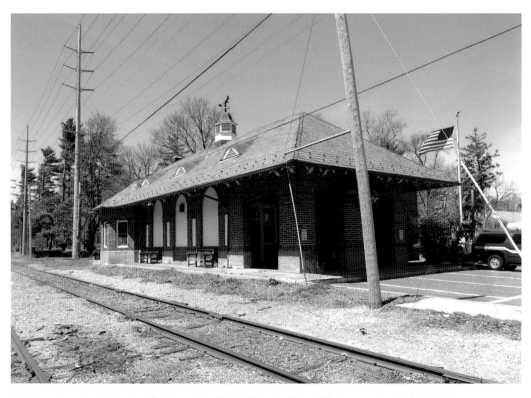

What was once the Clinton Road Station on the Central Branch of the LIRR is now a Garden City firehouse.

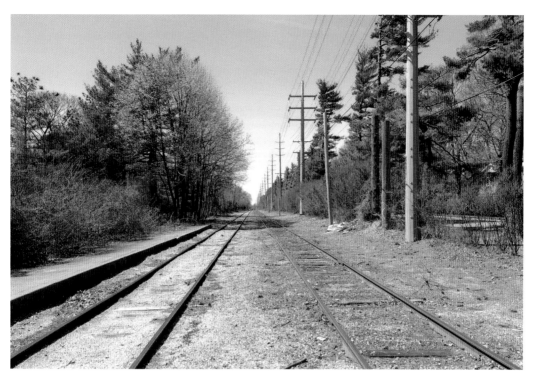

The concrete platform of the old Clinton Road Station is still present on the north side of the tracks at Clinton Road.

Lots of vintage debris lies along the tracks, including this half of an old brown ceramic insulator.

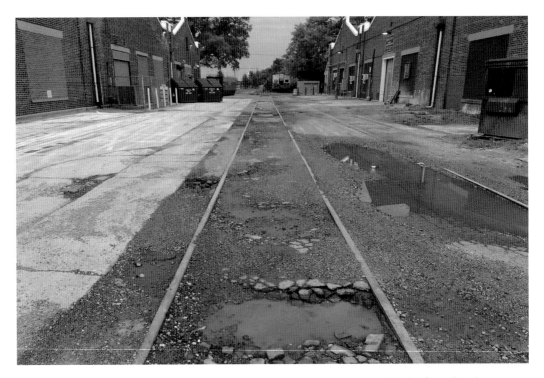

A rail spur off the tracks leads to warehouses at Mitchel Field, which would receive trainloads of supplies when both tracks and base were still active.

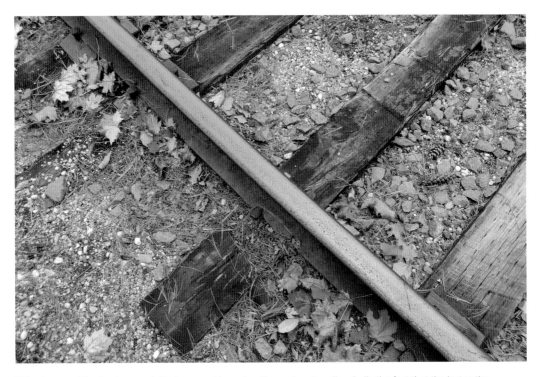

This closeup of the tracks reveals their age—old wooden ties and rusty spikes belie the fact that the last active use of this line was in 1953.

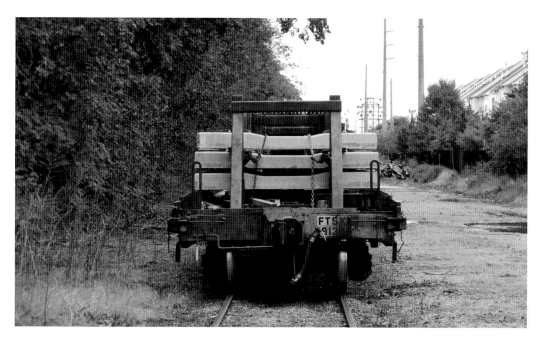

The tracks are used very occasionally by maintenance trains. This piece of equipment holds concrete railroad ties for future use somewhere.

A rusting piece of equipment sits in tall weeds just west of Endo Boulevard.

All kinds of forlorn, broken equipment can be found along the tracks east of Clinton Road.

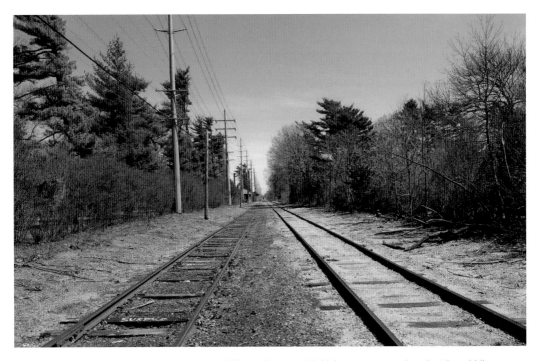

Looking east from a couple of hundred feet west of Clinton Road, you'd think you were anywhere but the middle of Garden City.

The remains of an ivy-covered Central Railroad bridge are hidden on a hill between the Meadowbrook Parkway and one of its ramps.

The furthest east the tracks go is through a parking lot on Endo Boulevard, usually covered in puddle water if it has rained any time in the last few days.

3

ST. PAUL'S SCHOOL

Abandoned places run the gamut in size and importance, ranging from small, unsung and hidden barns, outbuildings, and garages, to massive, beautiful structures very much in plain sight, such as the St. Paul's School at the intersection of Stewart and Rockaway Avenues in Garden City. Built in 1879, the impressive 500-room Episcopal school for boys was conceived as a memorial to Garden City's founder, Alexander T. Stewart (1803-1876) by his widow Cornelia Mitchell Clinch Stewart (1802-1886). This Victorian Gothic building was designed by William H. Harris, and served as a college preparatory school for some of the nation's most well-heeled children. Alumni from the first decades of its prestigious existence included James Rudolph Garfield (son of President James Garfield), Cornelius Vanderbilt III, John Jacob Astor IV (who died on the *Titanic*), and world-famous polo player Tommy Hitchcock Jr. Later alumni include Donald Trump's two brothers (Trump's father was a donor of money toward soccer field improvements in 1956), Secretary of State John Kerry, Senator Sheldon Whitehouse, actor Judd Nelson, and John Lindsay (mayor of New York City).

The school closed in 1991 and the 150-foot-high building was purchased by the Village of Garden City in 1993 as part of a 48-acre deal made with the Episcopal Diocese of Long Island. Since that time, village officials and residents have been unable to agree on the building's fate. Some wanted it demolished, others wanted it saved. In 2003, the Preservation League of New York State put St. Paul's on its list of "Seven to Save," describing the most important threatened buildings in the state. Over the years, many proposals to reuse the space have been put forth (and gone nowhere), including turning it into a condo complex, an assisted living facility, and a library.

In 2018, a new proposal was put forth, in front of a crowd of hundreds of village residents, to turn the former school into a recreation center with an ice hockey rink

as its centerpiece, but that proposal was criticized for its large-scale gutting of the historic building interior. Preservation is often a tightrope walk, especially in places where there is no landmark status protection for structures. The intention is often to try to save a building, but as far as preservation is concerned, where there's a will, there isn't always a way. Sometimes gutting the interior is the only viable way to save a building—in this case, preserving the inside would mean finding a way to reuse a 500-room setup. Historically or architecturally important abandoned buildings often wind up victims of the wrecking ball, because as expensive as that is, it is still cheaper than rehabilitation of a behemoth old building. And when nobody can agree on a building's fate, it makes everything that much more complicated. Meanwhile, the old St. Paul's building continues to deteriorate, with holes in the roof and windows allowing water inside, its decay threatening its viability as a salvageable historic structure.

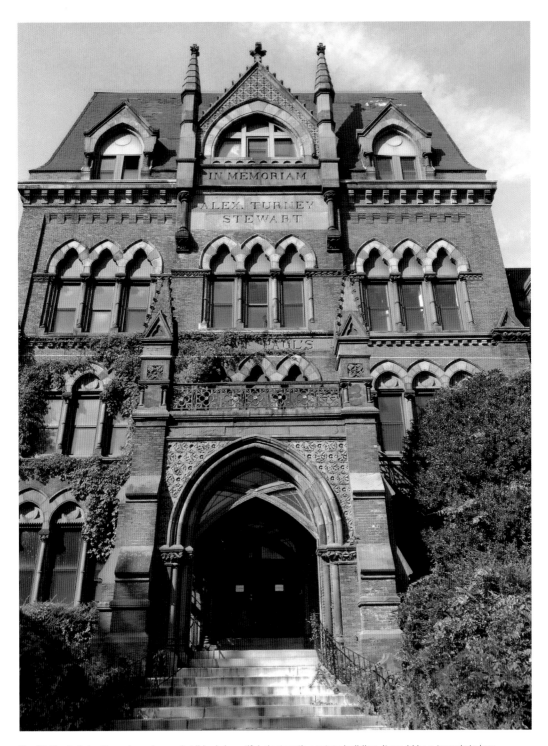

The St. Paul's School is an imposing and strikingly beautiful nineteenth-century building. It would be a tragedy to lose it, but as with any old building, the debate always centers around how to fund preserving it and what to reuse it for.

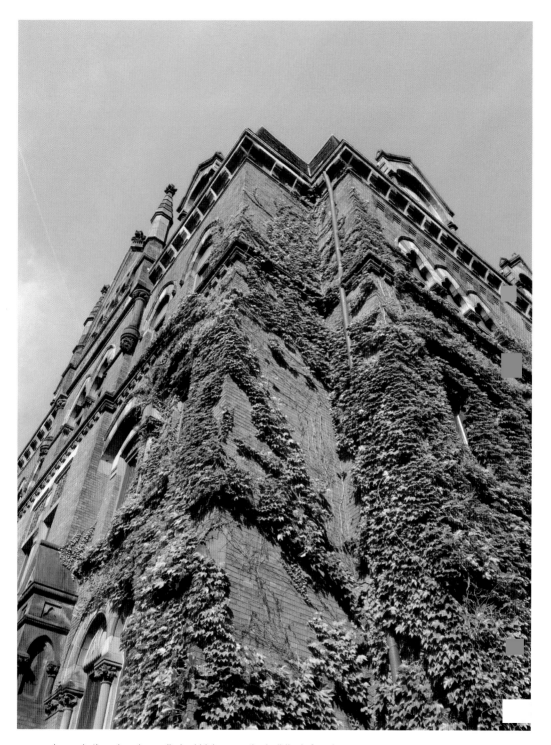

Ivy and other vines have climbed high up on the building's façade.

The clock tower is one of the building's most interesting features.

A pile of old bricks sits behind the abandoned school. The P&M stands for the Powell & Minnock Brick Company in Coeymans, New York.

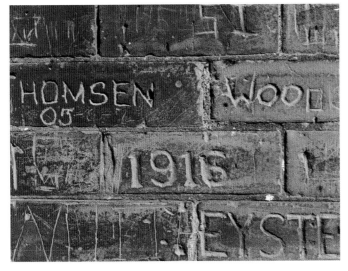

The names St. Paul's students carved on the building's bricks are still legible, a permanent record of their time at the school … or at least for as long as the building stands.

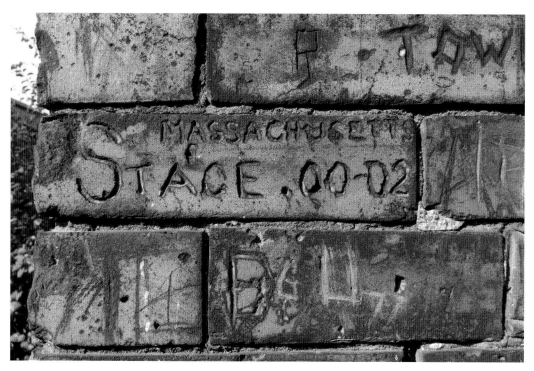

A student from Massachusetts named Stace carved his name and the dates of his attendance at the school on a brick. And yes, that's 1900-1902.

This view offers a peek inside the building through a broken pane of glass, upon which nearby tree branches are reflected.

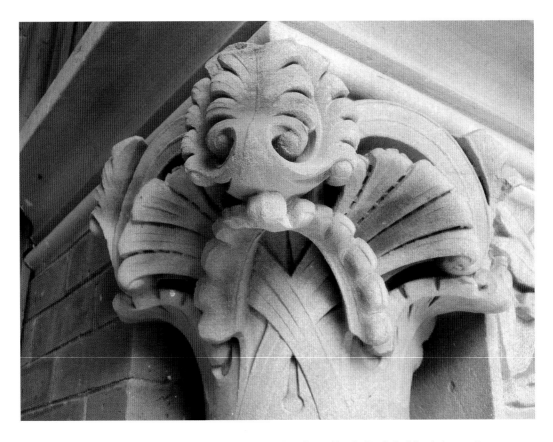

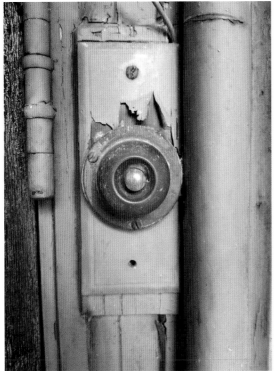

Above: The St. Paul's building is impressive from a distance, but also up close; the stone details are magnificent.

Left: A vintage doorbell harkens back to an era when the school was still thriving, several decades ago.

4

KING'S PARK PSYCHIATRIC

Building 93 of the abandoned Kings Park Psychiatric Center is probably Long Island's largest abandoned place. At thirteen stories high, this massive beauty towers over what is now the 521-acre Nissequogue River State Park (opened in 2000) on the north shore of Suffolk County, not far west of Stony Brook. The psychiatric center's origins date back to the late-nineteenth century, but Building 93 is vintage 1930s, an aesthetically pleasing Neoclassical-style high-rise constructed to house the many new patients that continued to arrive.

At its peak, the Kings Park complex included dozens of buildings (at least ninety-three of them, it would seem) and its population reached as many as 9,000 patients during the 1950s. Soon after, with the advent of new medications that reduced the need for as many people to be committed, the population began to decline. The hospital was closed in 1996, and since then, its buildings (some have been demolished but many still stand) are an eerie reminder of how those people with what are now easily corrected chemical imbalances used to be segregated from the general population—more eerie because of the serene, parklike setting that surrounds it.

Though from a distance it looks to be in good condition, you can see that most of Building 93's windows are shattered, adding to its abandoned (and vandalized) aesthetic, and despite a strong police presence on the grounds, there are many who venture beyond the fence and into the building, which has a reputation as being haunted by the ghosts of patients past. Indeed, there is something very creepy and mysterious about the place. When I visited, I remember only getting a cell phone signal in one spot—a tiny 3-square-foot zone a few feet away from the northern edge of the building. A step outside that spot and all connection was lost and I had no way of reaching the outside world. Ghosts? Probably not, but strange, for sure.

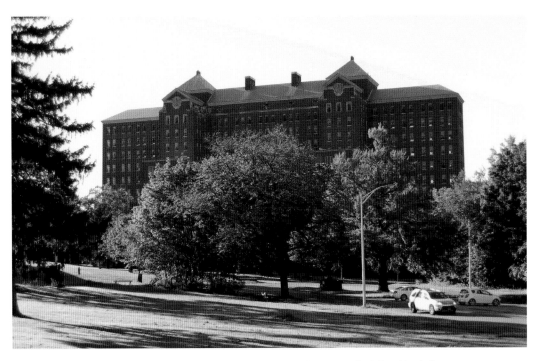

Long Island's most imposing abandoned building, aka Building 93 of the King's Park Psychiatric Center, towers over the parking lot for Nissequogue State Park.

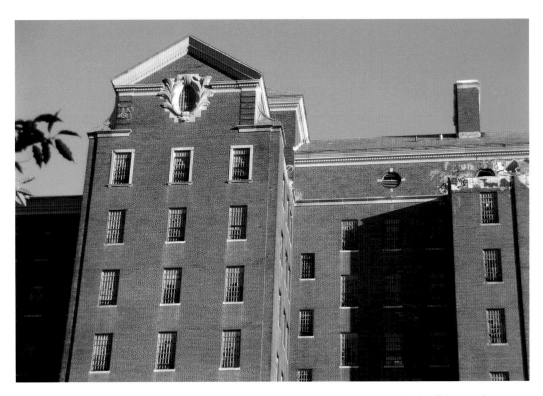

A closer look at Building 93 reveals some classical touches. Though the King's Park complex itself dates to the 1880s, this building is vintage 1930s.

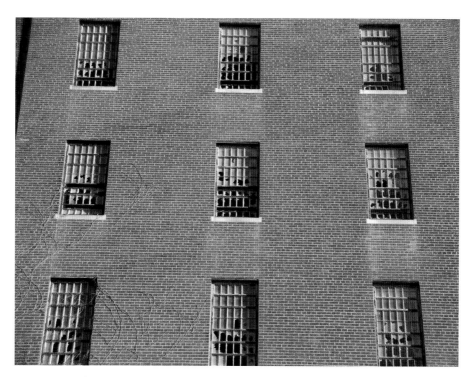

The thousands of broken window panes on Building 93 create a mesmerizing, haunting appearance.

An old door lies half buried under leaves, dirt, and twigs, among other debris outside the main building.

Wandering around abandoned structures, you'll inevitably see some mysterious objects that have a story to tell, if only they could talk.

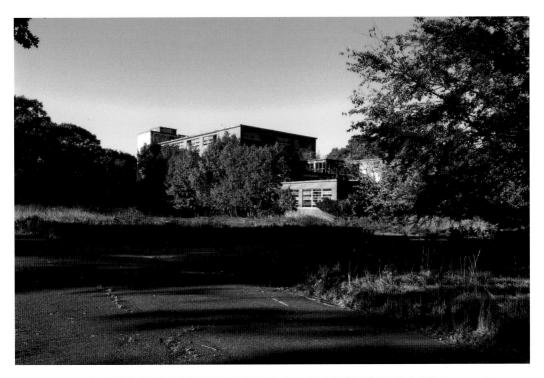

There are several other abandoned buildings on the King's Park campus besides the main building.

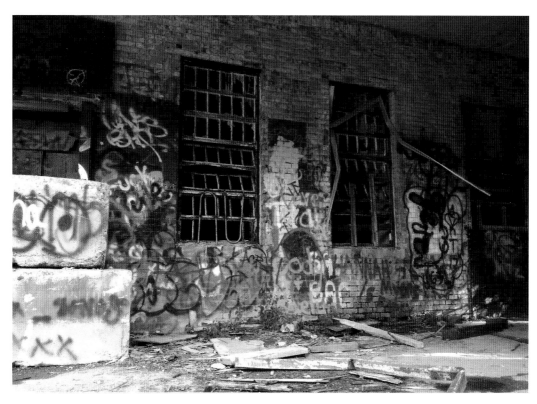

The back entrance to Building 93.

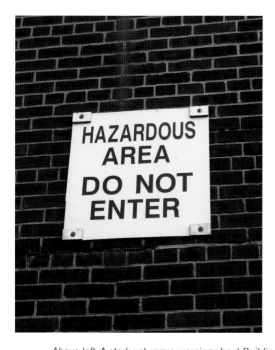

Above left: A stark yet vague warning about Building 93. Hazardous because of asbestos? Ghosts?

Above right: The warped remains of a chair sit on grass outside a King's Park building.

This piece of metal grating caught my eye. It's often the details, the little things scattered about an abandoned building, that speak the most to its former stately appearance.

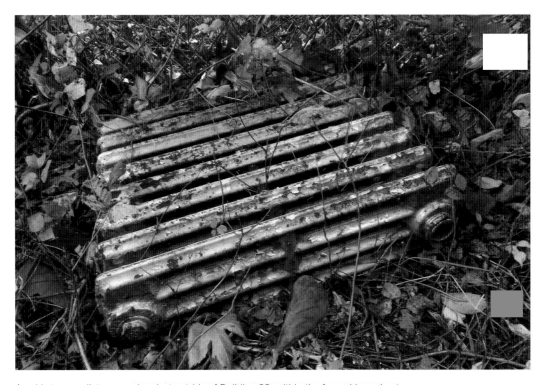

An old steam radiator wound up just outside of Building 93, within the fenced in perimeter.

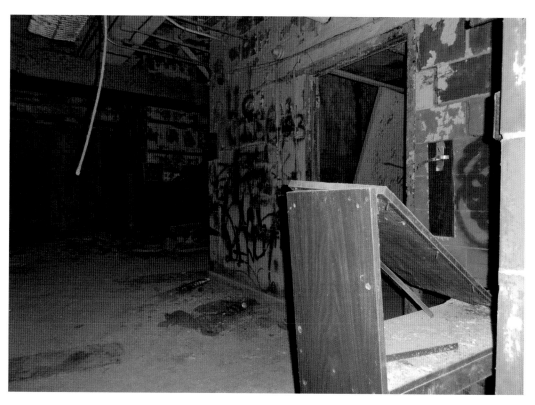

Above and below: An eerie peek inside the ground floor of Building 93.

5

WELWYN

The wealthy Pratt family certainly made their mark on Long Island's Gold Coast. The patriarch was Charles Pratt, who made his fortune in oil. He and his sons built mansions in the Glen Cove area, including Killenworth (now owned by the Russian government) and Welwyn. The latter was built in 1913 by Harold I. Pratt on a scenic plot of land overlooking the Long Island Sound. Pratt died in 1939, and his widow continued to live at Welwyn until her death in 1969, after which time the estate was given to Nassau County. The mansion was neglected and the property was closed to the public, used only by the Nassau County police for training purposes. In the 1990s, the mansion was renovated and converted into the Holocaust Memorial and Tolerance Center of Long Island. The rest of the property became the Welwyn Preserve, which offers waterfront views and scenic woodland hikes. Though the children's garden was restored, other parts of the estate were left to crumble. The 204-acre Welwyn Preserve today offers several outstanding ruins of estate outbuildings, a stark contrast to the stately museum-mansion a stone's throw away.

Clustered just east of the main house are some incredible abandoned structures. A large garage building is likely where the Pratt vehicles were once stored. Even in its decayed state, its opulence is still noticeable in the white tiles that line the interior walls. A little further lies what was once an elegant brick building with a large chimney, which must have served as a grounds crew prep and storage building based on the lockers, shelving, and large porcelain sinks. Beyond that are the graffiti-covered ruins of a whimsical log cabin, perhaps a playhouse for the Pratt child, Harold Jr. (born in 1904). Further along a winding cobblestone path is the greenhouse complex, which has achieved a cult status among those adventurers who frequent it. On my first visit, there was a young man sitting outside the building strumming a guitar, and on my second visit a young woman was doing acrobatics hanging from the steel

skeleton of the greenhouse while being photographed by a friend. The two-story greenhouse storage building is filled with amazing artwork spray painted on every available wall, some of the most colorful and inventive graffiti to be seen anywhere on Long Island. Empty spray paint cans litter the floors, a testament to the creative fervor of the artistic shrine's visitors. The second floor of the building leads out to the skeletal greenhouses themselves, their glass long gone, a corner of which has been turned into an eerie but fun shrine of sorts—a shrine to creativity featuring creepy stuffed animals hanging from above, and various "offerings" laid out on a table. A visit to Welwyn is trippy fun and a tribute to what abandoned can mean to those who appreciate it, truly a place where the skeletons of the past come alive with the color of the present.

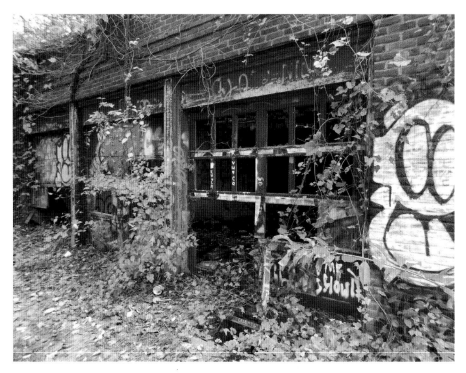

The Welwyn garage is near the main house and close to the parking lot, so it gets a lot of visitors, both intentional and unintentional.

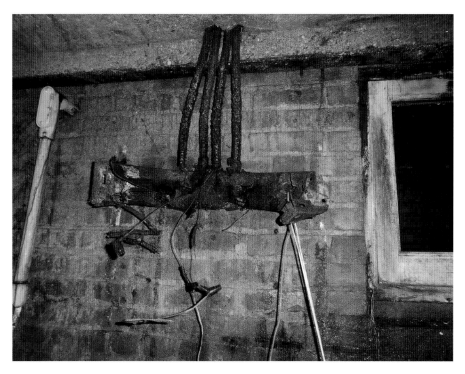

The garage basement, however, does not get many visitors and is surprisingly unmarred by graffiti. It was so dark, flashlights were necessary to see, and this rusty electrical equipment caught my eye.

A warped, flash-lit screen in a far corner of the basement of the garage makes for an eerie photo against a pitch-black background.

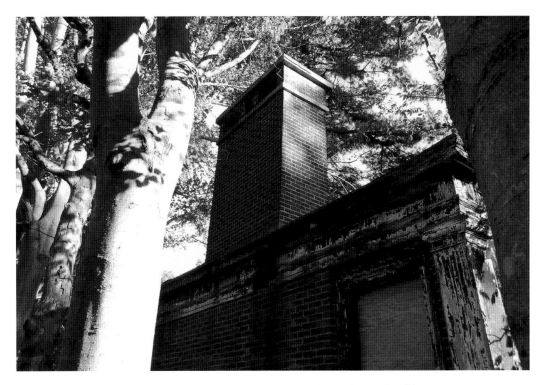

A mysterious abandoned brick building near the main house has an impressive chimney.

Several large ceramic wash basins in this building give hints to its past. It was likely a storage and preparation outbuilding where estate workers could change, wash, and store supplies.

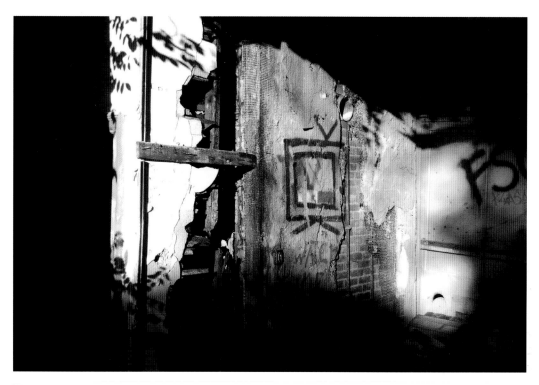

The building is highly unstable; its walls and floors are caving in.

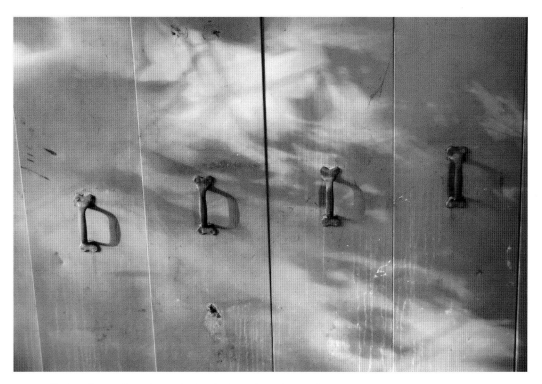

The handles on these vintage lockers in the building have a nice patina.

Pieces of wall and ceiling litter the floors.

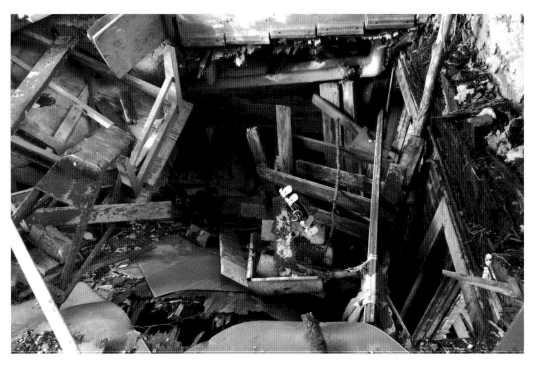

Abandoned buildings are dangerous. Another step or two and I'd have fallen into a pit of despair, through a heap of sharp wood, metal, and glass debris into the basement.

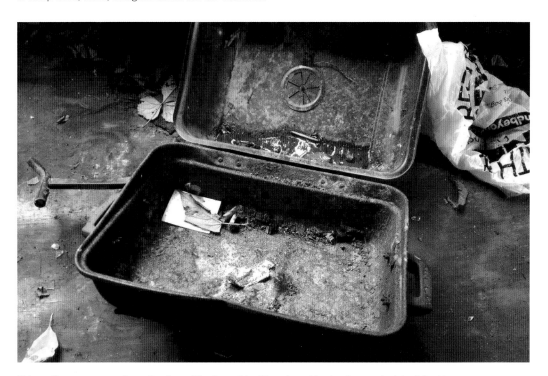

This rusting, open case sits on the floor of the log cabin. When I went back a few weeks later it had been spray-painted pink and blue. Abandoned places are constantly changing, whether from continued decay or human interference.

Right: Abandoned places offer bizarre sights like this—half a table laying in a patch of English ivy in the woods.

Below: Even the trees in this magical place get the graffiti treatment.

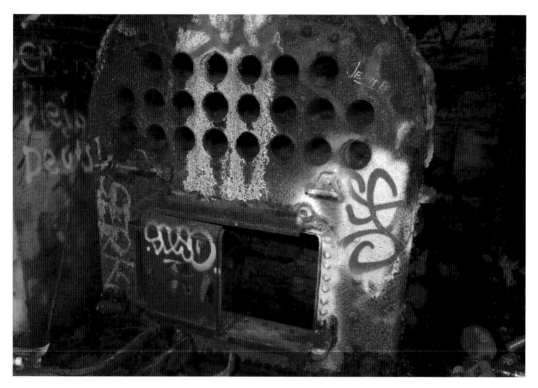

A furnace in the basement of the greenhouse complex.

Crumbling paneless windows are stacked in the basement of the greenhouse building complex.

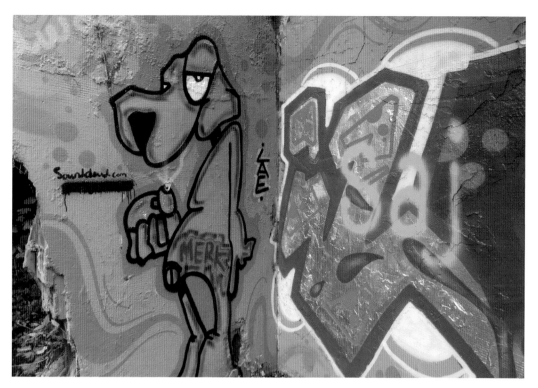

The second floor of the greenhouse complex is comprised of several rooms worth of amazing graffiti art.

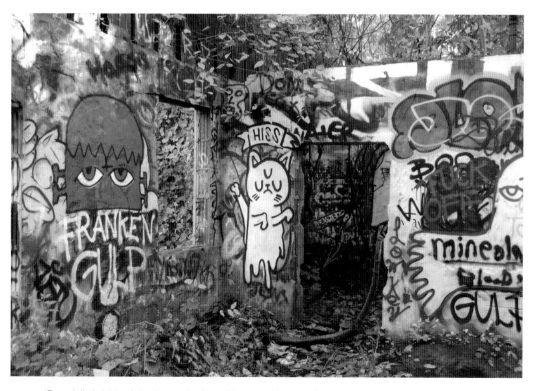

Especially bright paint colors make for striking art in the greenhouse building.

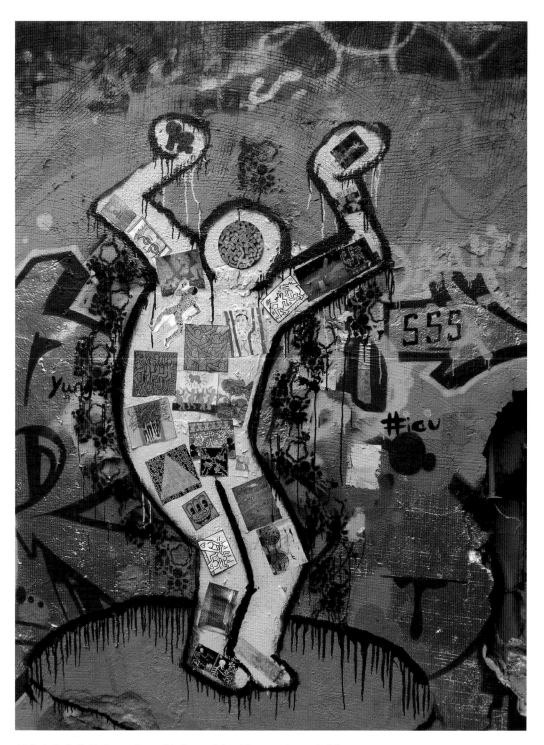

A tribute to Keith Haring on the wall in the upstairs of the greenhouse building.

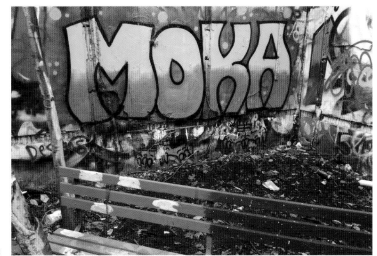

Empty spray paint cans litter the floors of the building's several rooms

Defunct electrical wires stick out of the wall between rooms in the upstairs of the greenhouse building

A pair of radiators in the greenhouse building most likely were toppled and/or moved by visitors.

Leaving the greenhouse building, you enter the remains of the greenhouses themselves, devoid of glass, just metal skeletons.

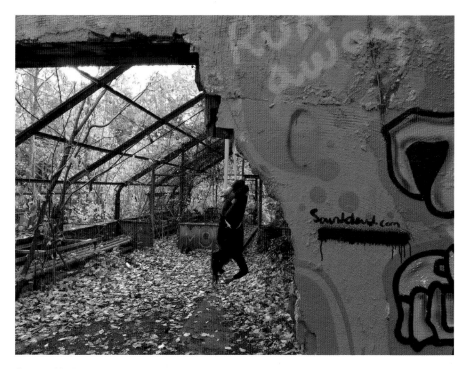

On one visit, I encountered a young woman doing some … let's call it acrobatics … while suspended from the greenhouse frame.

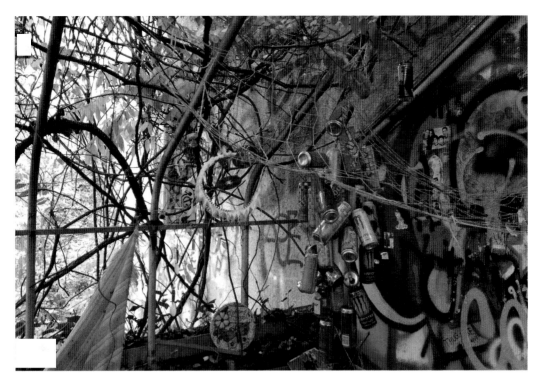

One corner of the greenhouse is an ever-changing shrine of sorts, with all kinds of creative displays ranging from hanging cans to stuffed animals to stickers, signs, and messages.

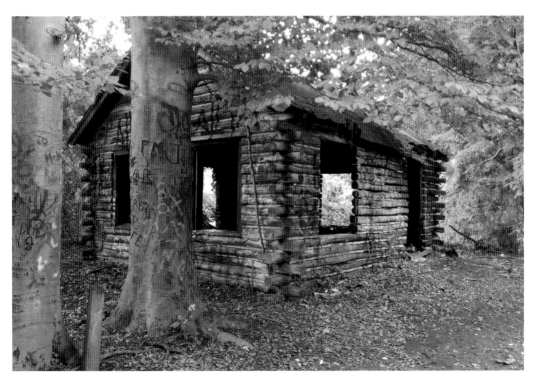

This old log cabin was surely a play house for the Pratt son.

6

THE LONG ISLAND MOTOR PARKWAY

The Long Island Motor Parkway (aka the Vanderbilt Motor Parkway) was the world's first limited access concrete highway. Devised by automobile enthusiast William Kissam Vanderbilt Jr. (1878-1944; grandson of Commodore Cornelius Vanderbilt), work on the Motor Parkway began in 1908, at a time when much of Long Island consisted of messy dirt roads. The new highway was also special because it was completely grade separated from other existing roads and railroad tracks. There were sixty-five bridges carrying the parkway and over the parkway along the route.

About nine miles of roadway were complete by the end of 1908, the section from Westbury to Bethpage. By 1910, the parkway extended from Mineola to Lake Ronkonkoma, and by 1912, the parkway extended as far west as Springfield Boulevard in Queens. By 1926, it had reached its westernmost point, what is now Horace Harding Boulevard in Fresh Meadows.

The highway was not for the average citizen; when it was built relatively few people even owned cars. Plus, there was the price of admission: the toll on the Motor Parkway was originally $2.00 (which was a lot back then), then it fell to $1.50, $1.00, and finally 40 cents in the 1930s. Though it was innovative and impressive when conceived, by the 1930s, Long Island had already outgrown the narrow, curvy roadway. The bigger, faster cars of the '30s were a far cry from those of 1910, and besides that, the number of car owners on Long Island had skyrocketed. The construction of the wider Grand Central Parkway/Northern State Parkway in the early 1930s doomed the Long Island Motor Parkway to obsolescence. The old highway was decommissioned and sold to New York State for $80,000 in 1938. Much of the original highway property wound up being used as right-of-way for power lines. Most of the historic highway was ripped up over the years, but there are a surprising number of abandoned remnants of Vanderbilt's legacy left on Long Island.

Pieces of original abandoned roadway, of varying lengths and in varying states of preservation, can be found scattered across Nassau and Suffolk Counties. The best-preserved original Motor Parkway segment on Long Island lies in Albertson/ Williston Park, on either side of Willis Avenue. On the east side of Willis Avenue, the old Parkway is now an access road for parking lots; it's the only drivable section of original Motor Parkway left. Just east of this near Roslyn Road, another stretch of Motor Parkway about a quarter mile long exists up an embankment just south of Croyden Court. Covered with tree limbs, weeds, and debris, the original parkway pavement and some concrete posts are still visible. More of the parkway's remnants lie in Mineola just north of Westbury Avenue; hard to see in person but easy to see in an aerial view. In Suffolk, there are abutments of a bridge that once spanned over a farm in Melville, as well as a stretch of original pavement heading east from there. To this day, "new" remnants are being discovered by enterprising adventurers with a sharp eye.

A few of the old parkway toll lodges also exist. One in Mineola and another in Williston Park were converted into private residences. The best-preserved lodge is the Garden City lodge, moved from its original location at Clinton Street to Seventh Street just off Franklin Avenue, where it now houses the Garden City Chamber of Commerce.

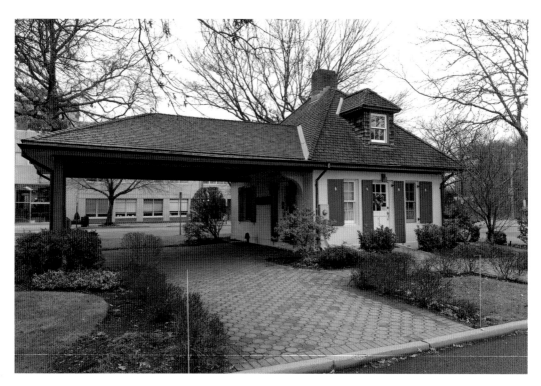

The Garden City toll lodge was moved from Clinton Road to its current location on Seventh Street, off Franklin Avenue, where it now houses the Garden City Chamber of Commerce.

The only original, drivable section of the Motor Parkway on Long Island is just off Willis Avenue on the border between Albertson and Williston Park.

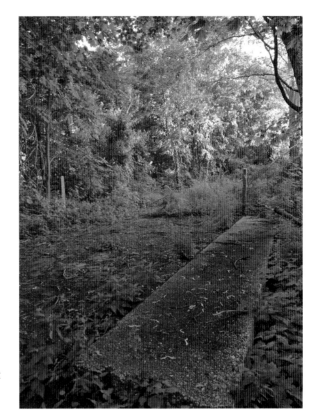

Right: A pair of concrete posts and a section of original Motor Parkway curb are visible in a strip of woods off Roslyn Road just south of Croyden Court on the border of Roslyn Heights and East Williston.

Below: A remnant of Motor Parkway just north of Westbury Avenue in Mineola is still visible.

The abutments of the Ezekiel Smith Farmway Bridge remain on Maxess Road in Melville. The bridge crossed over the Motor Parkway to allow the farmer safe access to all of his farm, which was sliced by the parkway.

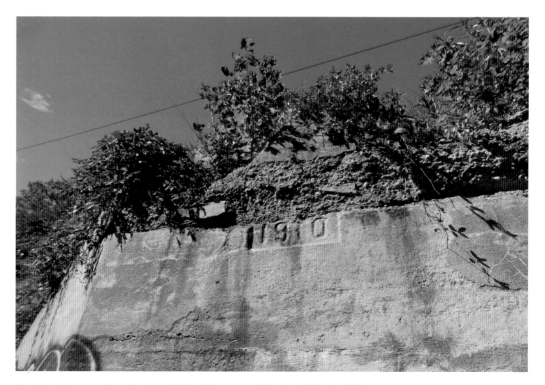

The date of construction of the Ezekiel Smith Farmway Bridge is still clearly visible.

LIPA power lines are a common sight along the Motor Parkway right-of-way. Since the State of New York purchased the defunct Motor Parkway in 1938, much of the right-of-way is on state-owned property and thus was a perfect place to run power lines.

Close-up view of a remaining piece of roadway in Melville, just north of Ruland Road. New remnants of the famous highway are still being discovered tucked away, with more exploration and better precision mapping of the parkway's exact route.

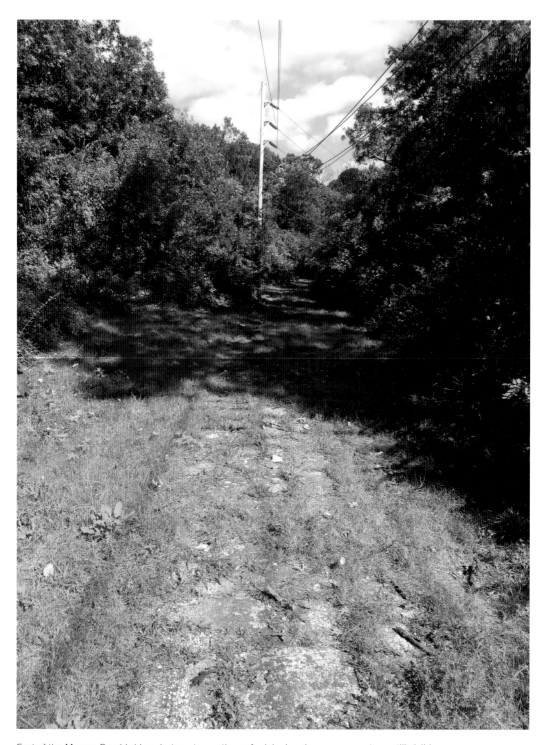

East of the Maxess Road bridge abutments, sections of original parkway pavement are still visible.

7

KNOLLWOOD

egendary ruins lay waiting in the woods on the southern part of the 550-acre Muttontown Preserve in Nassau County, on what used to be a 150-acre estate called Knollwood (built 1906-1920 for a wealthy businessman named Charles Hudson). In its heyday, the estate's centerpiece was a thirty-room mansion with thirteen bedrooms and eleven bathrooms, which overlooked lavish gardens. The estate led a quiet existence for more than thirty years, until it was purchased by Albania's last monarch, King Zog I (born Ahmet Muhtar Zogolli; 1895-1961), who had fled to England with his family in 1939, on the run from Mussolini's army. King Zog moved to Egypt in 1946, but harbored serious dreams of moving to America. In 1951, he decided to make that dream come true, and bought Knollwood with the intent to bring his staff and move to Muttontown.

But years passed and Zog remained abroad, so he decided to give up his dream and just sell the American estate in 1955. It was then purchased by a local named Landsdell Christie; however, rumors spread that Zog had royal treasures buried on the property in advance of his arrival, and vandals began to wreak havoc on the property looking for the supposed loot. Knollwood mansion was torn down in 1959, and the estate was soon after sold to Nassau County. But while the mansion itself was obliterated, not everything of Knollwood was destroyed. Enough remains of Zog's would-be home to create a poignant, eerie reminder of past glory: garden walls, steps, ruins of statuary, columned gazebo structures, and brickwork.

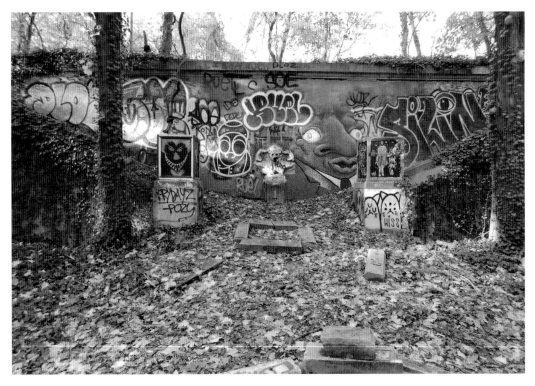

The main ruin of Knollwood is the double staircase that led from the gardens below to the mansion and its terrace overlooking the gardens.

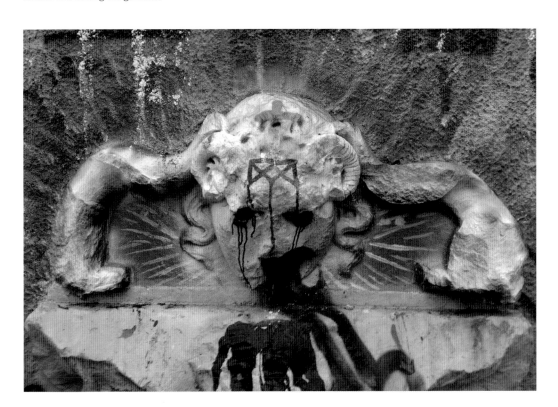

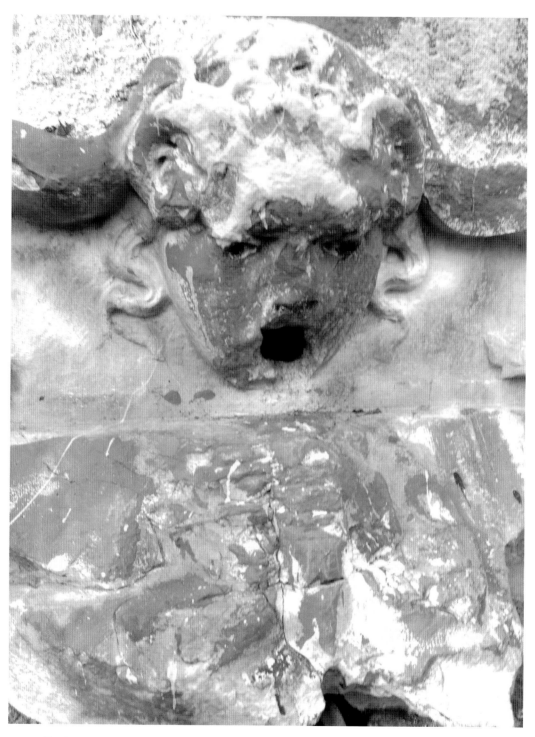

The focal point of the grand staircase from the gardens to the mansion was a stone fountain, seen above in 2015 and on the previous page in 2018, seriously defaced.

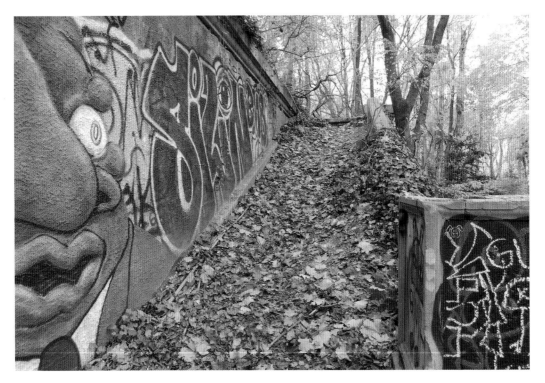

What used to be steps up to a beautiful terrace upon which the mansion was built is now just a steep and occasionally treacherous dirt slope that leads to a wooded plateau.

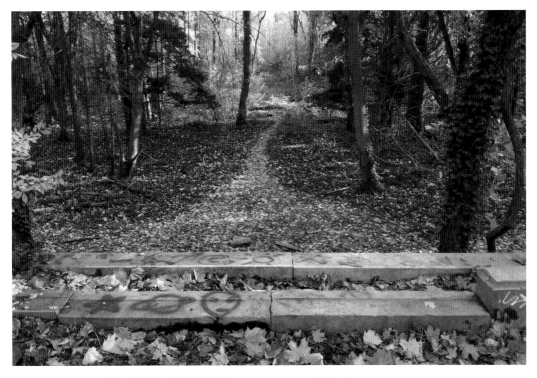

The view looking down from atop the steps was, before 1959, of beautifully landscaped gardens.

A series of bolts that once held in place the decorative railing on both sides of the grand staircase.

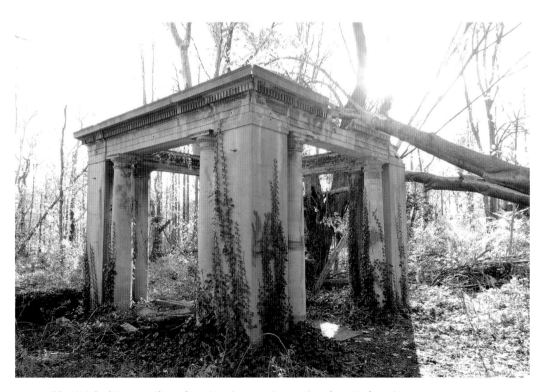

What is left of the magnificent formal gardens are the remains of a pair of gazebos.

Abandoned places offer would-be poets a chance to leave behind public musings about life.

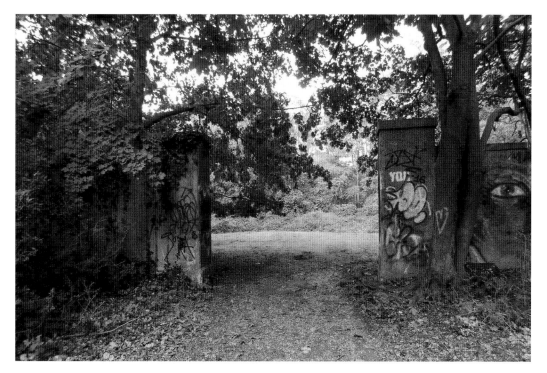

The remains of the walled garden, which were some distance from the mansion, are accessible down a relatively straight and wide path from the equestrian center parking lot on Route 106. This is a safer part of the ruins of Knollwood to visit than the rest, which is along a narrow path in a tick-infested part of the preserve.

The small faucet on the interior of the walled garden has not been used in over sixty years.

The remnant of an irrigation system just inside the walled garden.

Abandoned places offer many visually interesting mysteries. This metal bracket inside the entrance to the walled garden could have been … ?

8

CHELSEA MANSION

Muttontown Preserve, Nassau County's largest nature preserve, is home to more than just one estate's abandoned ruins. Cobbled together from three separate estates over time, the preserve's two sets of ruins are unrelated. At the northeastern corner of the preserve, just off Route 25A, sits Chelsea Mansion, built in 1924 for Benjamin Moore, great-great grandson of Clement Clarke Moore ('Twas the Night Before Christmas), whose father was Bishop Benjamin Moore (the man who gave last rites to a dying Alexander Hamilton). Moore was very active in local politics and served as Muttontown's first mayor. After Moore died in 1938, his widow eventually deeded the house and property to Nassau County. She remained in the house until her death in 1983.

Designed by famous architect William Delano (a cousin of Franklin Delano Roosevelt), the forty-room Chelsea Mansion was named for the Moore family ancestral home "Chelsea" in Manhattan, which was the reason the neighborhood got its name. Today, the mansion is open for weddings and special events. Nearby outbuildings house an artist's studio, but further along the road from the main house is a greenhouse complex that has been abandoned and fallen to ruin. I find abandoned greenhouses especially fascinating subjects; they were designed as places to control nature in an orderly and logical way, but soon after their human caretakers leave, nature turns the tables and they are overtaken with weeds and vines that obey no rules except their own. Once carefully protected environments, they are now entirely open to the elements.

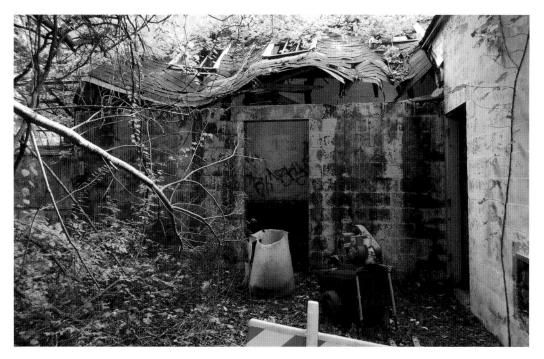

Several of the Chelsea Mansion buildings are still in use, but not the Chelsea Mansion greenhouse complex, which looks unassuming from the access road. Never judge an abandoned building by its cover.

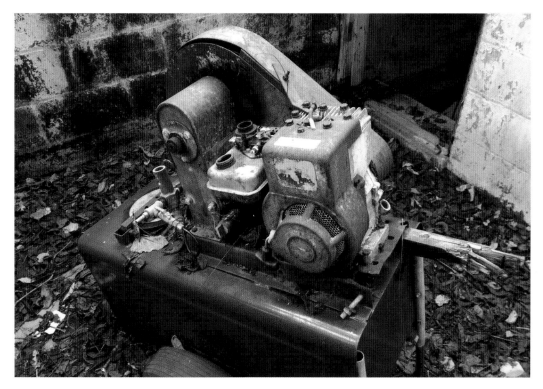

Some of the objects you encounter in abandoned places seem to have been viable and valuable things that were just left to rot in the elements.

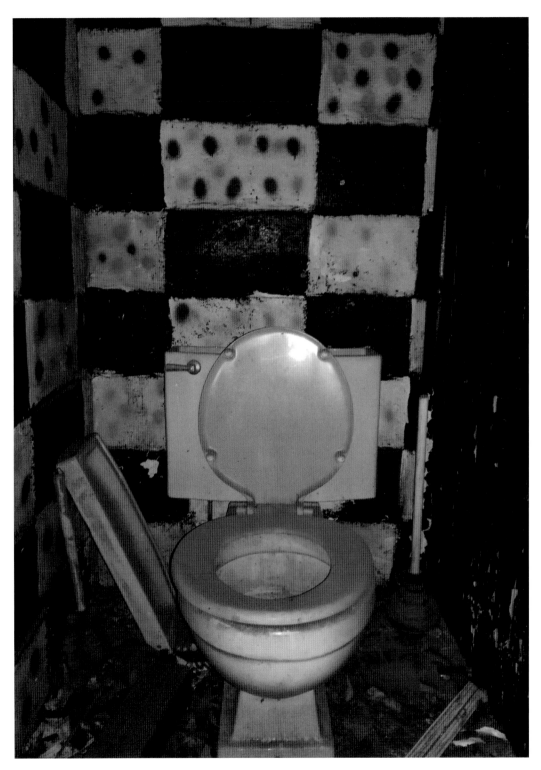

The greenhouse bathroom has been given a colorful makeover. And I just noticed in writing the caption that the plunger is still there! There are always so many details to see in abandoned buildings; taking photographs is essential for further study.

Dozens of scattered plastic pots could date from the late 1960s, since the widow Pratt died in 1969, after which the mansion fell into a state of neglect.

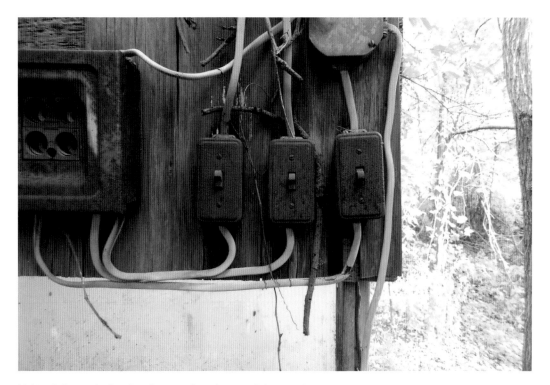

Light switches and a fuse box that once lit and powered the greenhouse.

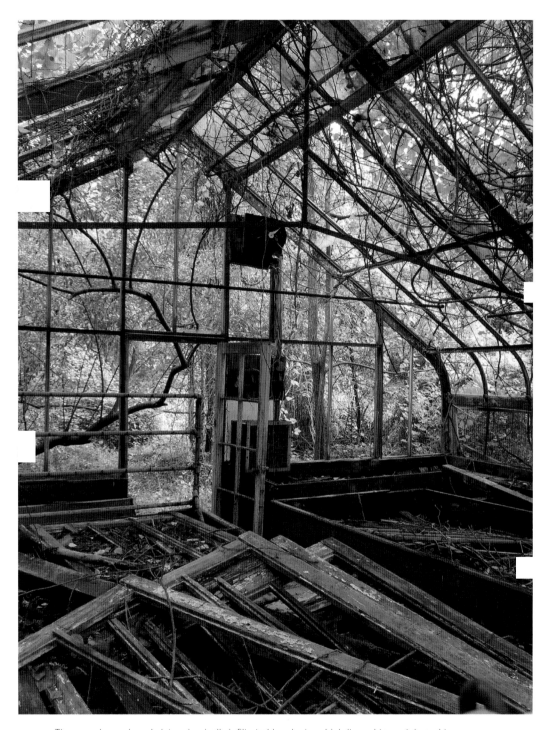

The greenhouse is a skeleton, ironically infiltrated by plants, which it used to contain and tame.

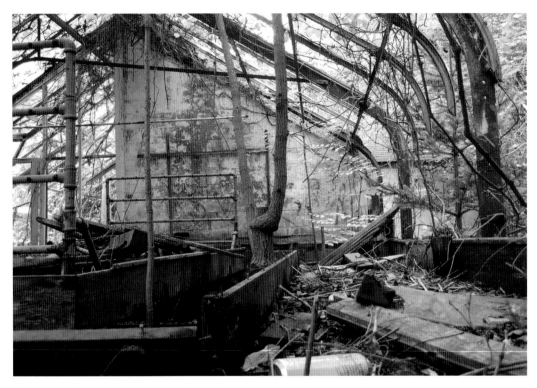

Broken wood, metal, brick, and glass are strewn about the greenhouse, from which a few trees are now growing.

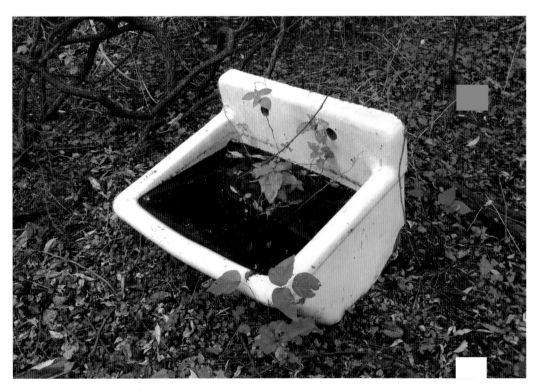

A sink in the woods. Because, why not?

9

MITCHEL FIELD

When the United States entered World War I, Central Nassau County's Hempstead Plains was the perfect place for the government to construct training camps. The flat, mostly untouched grasslands just east of the village of Garden City were ideal for pitching tents, drilling troops, and building runways. Thousands of soldiers trained at Camp Mills before shipping overseas. Located roughly between Oak Street and Clinton Street, the army base only lasted a few years before it closed. There are no physical remnants of Camp Mills—the former site is mainly private homes now—but the railroad tracks that once served it still exist (see chapter 2).

There are, however, plenty of physical remains of Mitchel Field, located just east of Camp Mills. The army air base was named after John Purroy Mitchel, the former mayor of New York City who died in a training plane crash in Louisiana in 1917. Mitchel Field thrived from 1917 all the way to 1961, when it was decommissioned.

At its peak in the 1940s, Mitchel Field was a massive complex of runways, operations and support buildings, and military housing. Most of the original wooden buildings had by this time been replaced with brick structures as the base grew. Mitchel Field played important roles during both World War I and World War II, as well as during the Cold War. But with continued development of the immediate area, by the late 1950s, it was no longer practical for military planes to take off and land in the middle of such a populated area; Roosevelt Field just to the north had closed in 1951 and much of the land developed as retail, including the Roosevelt Field Mall. After the base closed in 1961, much of the former runway area was ripped up and the land developed to become the Nassau Coliseum and the Marriott Hotel and their associated parking lots, and the Mitchel Field Athletic Complex. Several of the dozens of vintage 1930s and 1940s (mainly) buildings were given to the recently

founded Nassau Community College, which repurposed them as classrooms and administrative buildings. Dozens of stately officers' homes are still used as housing today, at a low cost for both active military personnel and veterans. Former hangars were preserved and reborn as the Cradle of Aviation Museum and the Children's Museum. The old commissary base building still serves that function—a supermarket strictly for members of the US armed forces. One of the most elegant base buildings still in use is the Mitchel Gynmasium on Miller Avenue, with its classical portico.

Because Nassau Community College is a two-year commuter school, its campus is empty when classes are not in session and its buildings (many in deteriorated condition) are pretty haunting. It is not hard to imagine them teeming with military personnel, just as standing on the former parade grounds you can picture drills taking place amid the roar of planes taking off.

But explore deeper within the Mitchel Field complex, behind and to the east of the museums, and you are in another world. An eerie, abandoned world. Of the shuttered buildings, the largest is the two-story Non-Commissioned Officers Quarters, directly behind the Cradle of Aviation. This brick building is simple, yet has hints of neoclassical elegance about it. Several other smaller buildings sit nearby, forlorn and empty, once vital parts of the Mitchel Field complex and now rotting, unusable and unwanted. While the future of these buildings is uncertain, as long as they still stand, they are a time warp to the past, frozen in a bygone era. One positive harbinger happened in 2018, when Mitchel Field was added to the National Register of Historic Places, opening the door for possible grants to preserve and protect the existing buildings that are still salvageable.

The last of the old Mitchel Field runways lies between a strip of the Hempstead Plains and Nassau Community College parking lots.

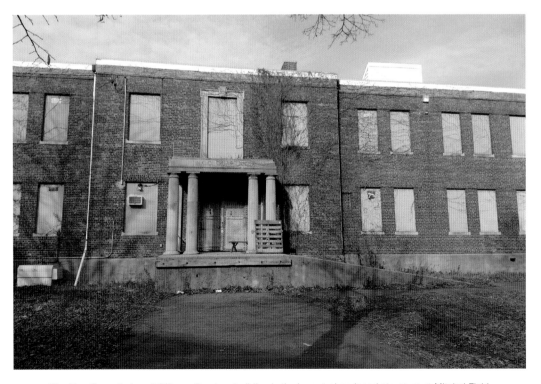

The Non-Commissioned Officers Quarters building is the largest abandoned structure at Mitchel Field.

Mitchel Field is full of vintage signs like this stenciled example that may well date to the 1950s.

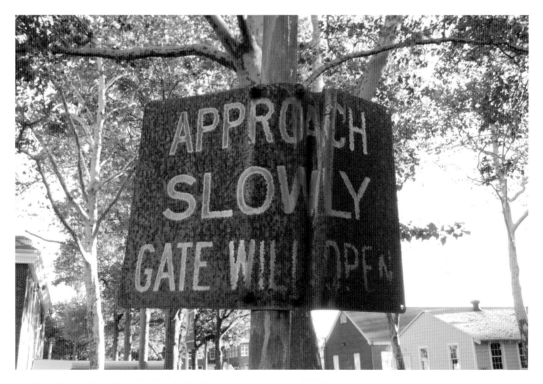

Another vintage sign referring to a gate that has long since stopped working.

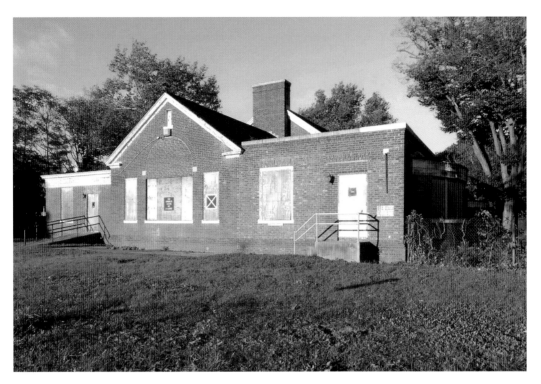

The juxtaposition of new and old at Mitchel Field is especially striking. Abandoned Building 108 is just feet from buildings that are currently in use by Nassau Community College.

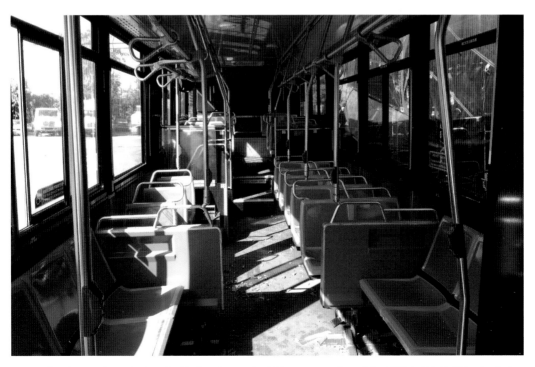

Random trucks and other disabled or damaged vehicles are sometimes left at Mitchel Field. This ghostly bus was not accepting any passengers.

Above and below: This building was originally the base radio station and then later, after Mitchel Field was decommissioned, it served as a Naval Exchange storage and maintenance building before it was abandoned, probably in the late 1980s.

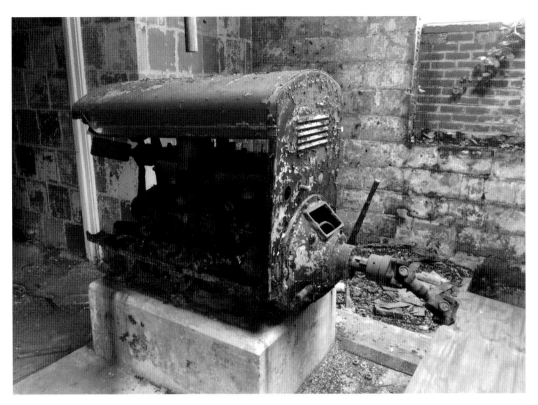

The larger and heavier the object, the more likely it is to remain intact in an abandoned building. Engines, boilers, furnaces, and the like can often be found rusting away, but mostly intact.

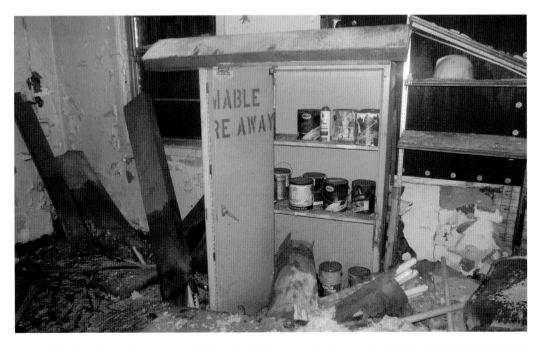

Paint and other maintenance supplies from the 1980s and earlier in an old storage cabinet. A blue bird painted on the wall is visible. The traces of red to its right and below are part of a much larger painted image that is obscured.

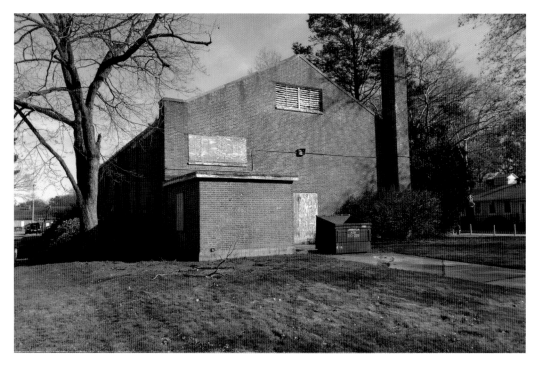

Building 107, vintage at least 1936 or earlier, was formerly the base theater, at one time known as the War Department Theater.

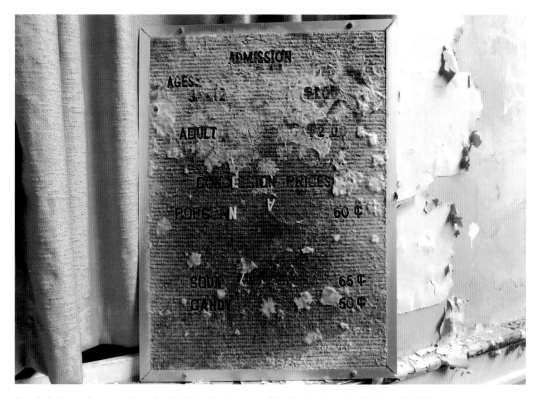

An admission and concession price list dates the last use of the theater to probably the mid-1970s.

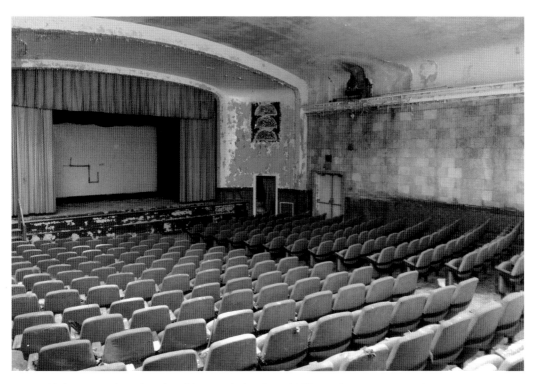

It's been a very long time since this severely deteriorated 300-seat theater saw any performances.

The roofs of abandoned buildings are often the first components to fail. Once a hole opens in a roof, things deteriorate quickly if nothing is done to repair it. Rain, snow, wind, and animals can get in and wreak havoc.

Several smaller abandoned Mitchel Field buildings are in the northwestern corner of the old base.

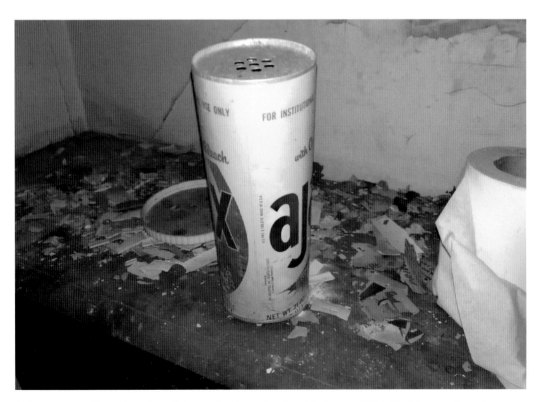

A vintage can of Ajax and a roll of toilet paper in a long-abandoned bathroom. Sights like this are quite eerie because it really is as if the building's inhabitants literally dropped everything and ran.

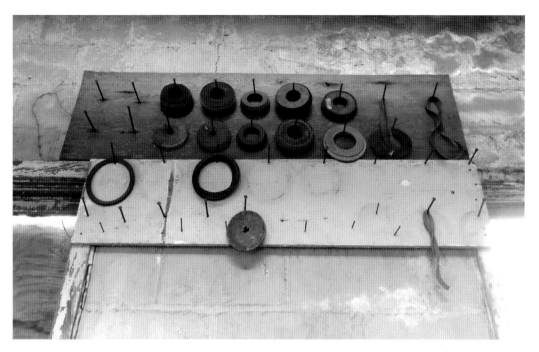

Old rubber gaskets still hang on the wall of one of the smallest abandoned buildings at Mitchel Field, clearly a vehicle repair shop or service building of some kind.

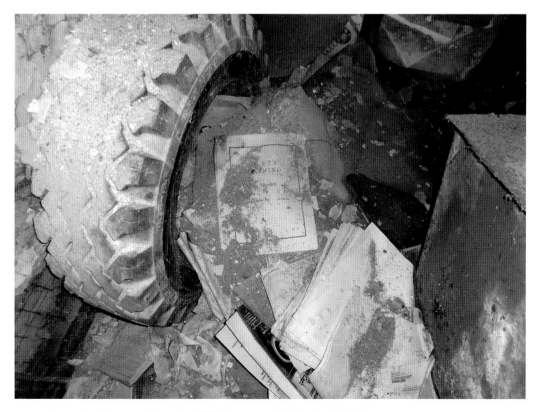

Irony – A safety manual from the 1980s lies covered with dust and debris.

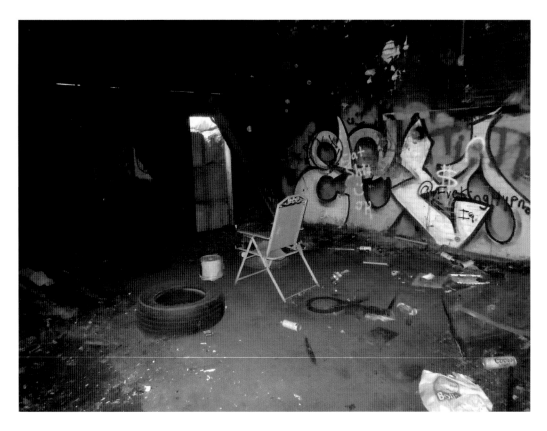

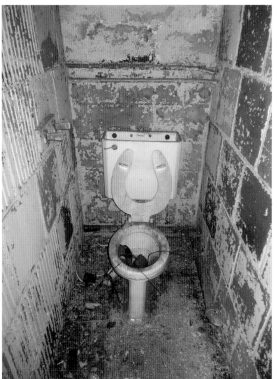

Above: Abandoned places often show signs of recent habitation. Someone has probably been sitting in this chair recently.

Left: A forlorn toilet in one of several abandoned support buildings. An ancient metal toilet paper holder is still bolted to the wall.

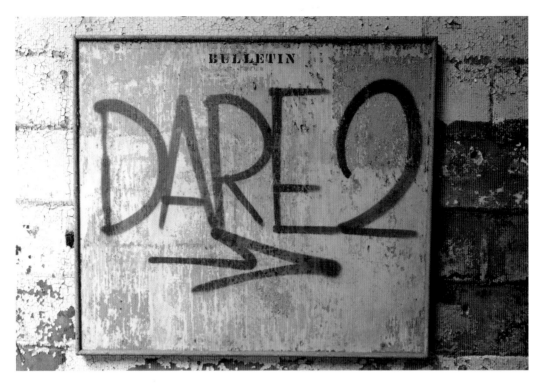

I love the juxtaposition of old and new in abandoned places. Recent graffiti adorns this vintage bulletin board with stencil painted lettering.

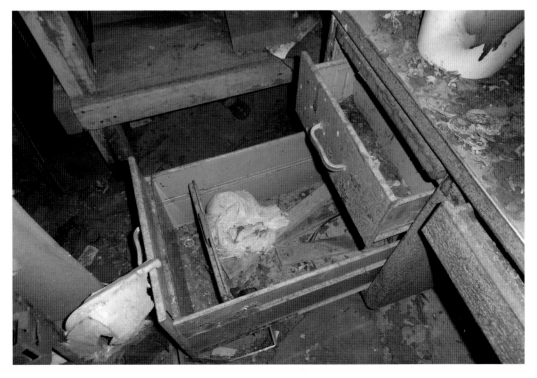

Both poignant and creepy—a rusting old desk with its drawers open.

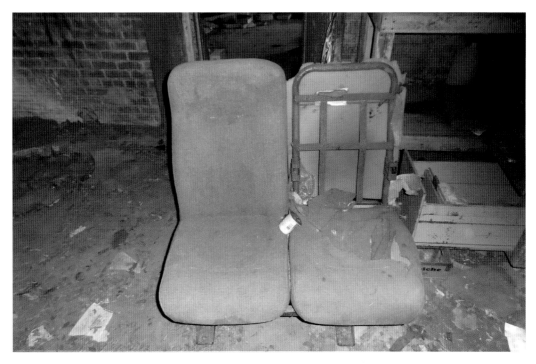

Scenes in abandoned buildings are often as surreal as a Dali painting. A cup of yogurt lays on a pair of seats ripped from some unknown vehicle on the floor of an abandoned Mitchel Field building.

Decay reveals interesting textures on walls and ceilings. I also like the rusting chain hanging from the ceiling in a support building. And if you look closely, you can see the freakishly long and sharp drill protruding from the wall.

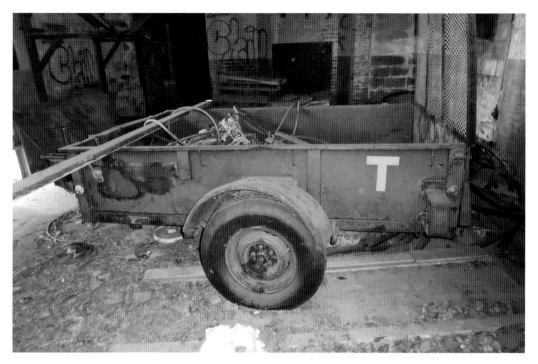

A vintage Trailevator trailer inside an abandoned building. Made by the MagLiner company, it is (or was) a hydraulic elevating trailer that lowers to the ground to accept a load and then raises to hauling level.

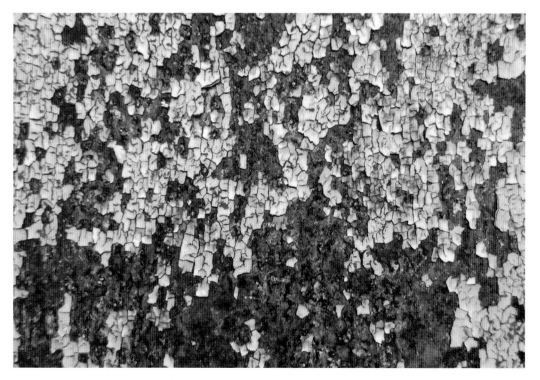

Decay can be art. My eye is often drawn to the patterns made by rust and chipping, peeling paint. This photograph is of the exterior to a door on Building 107.

10

FAIRCHILD REPUBLIC FACTORY

L ong Island was once home to two of the country's most important World War II (and Cold War) aircraft manufacturers—Republic and Grumman (Grumman, located in Bethpage, scaled back Long Island operations in the 1990s and the last vestige of the once-great industry is now Grumman Studios, where films are made). Founded in 1931 as Seversky Aircraft, Republic Aviation was based in East Farmingdale and was responsible for constructing over 9,000 P-47 Thunderbolt fighter planes during World War II. The company was acquired by Fairchild in 1965 and became known as Fairchild Republic. With the waning of the Cold War and a decrease in plane orders, however, there were extensive layoffs and the factory shut down in 1987.

Most of the buildings on the 91-acre property were demolished in 1997 to make way for the Airport Plaza Shopping Center on the east side of Route 110 in East Farmingdale. As of 2018, there was still a lone Fairchild Republic building on the north side of Conklin Street, abandoned and gutted by a devastating fire in 2015, a last vestige of a once formidable industry in Suffolk County. This massive 40- by 120-foot building, though now a mere skeleton of its former self, is still impressive in its sheer size. The former factory awaits its certain fate in an area that has seen much development in recent years. Republic Airport, which is adjacent to the former aircraft factory, still operates today just to the southeast of the building.

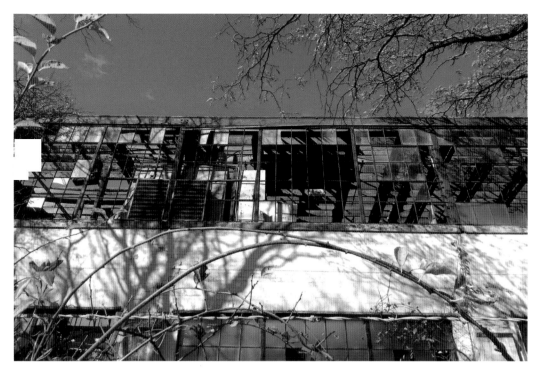

There is usually a point of no return for an abandoned building, after which there is too much damage to salvage it—and the Fairchild Republic building, after its fire, has most likely reached that point.

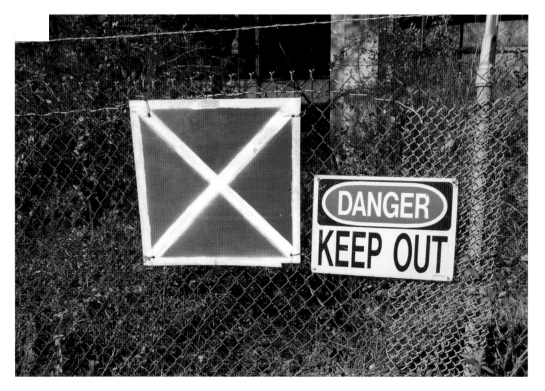

A standard danger sign accompanied by a rare hand painted version of the x-in-the-red-box sign.

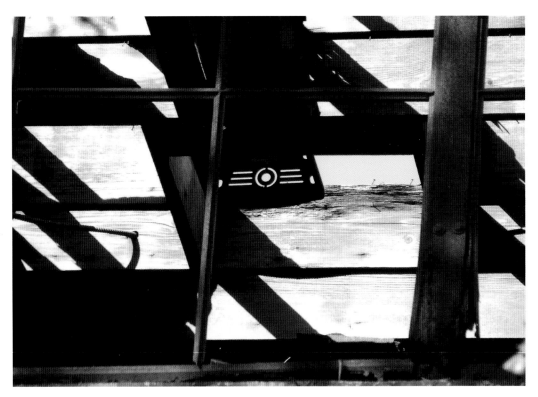

The stylized, Art Deco design on the light fixture in the building gives a hint of its former grandeur.

A building entrance, overgrown with weeds, fronts Conklin Street.

Pipes are often among the last components of a building's infrastructure to remain after abandonment.

The roof is completely gone in this part of the building and it makes for a dramatic view, with vine tendrils wrapped around the rusting framework.

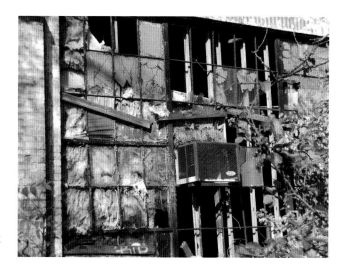

The rusted remains of an air conditioner sit precariously among broken window panes.

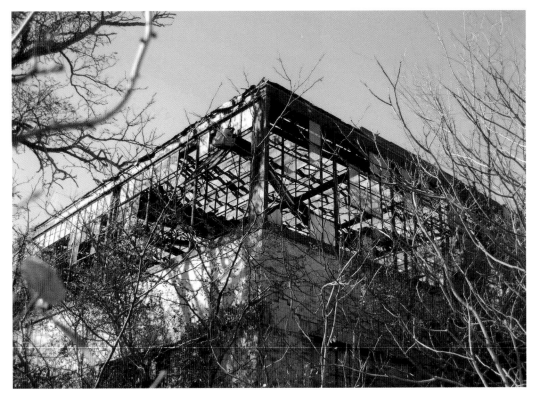

The southwestern corner of the building, closest to Route 110.

Who says a can of spray paint is necessary in order to leave one's mark on an abandoned place?

11

THE MALL AT THE SOURCE

Founded in Brooklyn in the 1920s, the Fortunoff department store had since 1964 been a fixture on Old Country Road in Westbury, near the site where Lindbergh's plane famously took off in 1927. By the 1990s, further retail development of the area was eyed, and in September 1997, the 763,000-square-foot Mall at the Source opened in Westbury with sixty-five stores or kiosks, including the 213,000-square-foot Fortunoff store, and parking for 4,000 cars in lots and a multi-level garage. When it opened, all but 40,000 square feet of space was leased.

The mall originally included a Virgin Megastore and an elaborate 375-seat Rainforest Café, in addition to a food court that offered everything from burgers and steak sandwiches to Chinese, Japanese, and Italian food. The idea behind the mall was to provide a good selection of off-price merchandise in addition to regular retailers such as Yankee Candle and Waldenbooks. Things seemed swell at first, but already by 2000, there were signs of trouble. When the Rainforest Café closed in October 2000, a victim of lack of repeat business, it was already the fourth eatery to shut its doors. Retailers had also been leaving after just a couple of years, including ABC Carpet and Home and Haggar Clothing Co. Their complaint, that the mall did not attract enough shoppers, was a serious issue and would ultimately become the death knell for The Source Mall.

In 2009, both of the mall's anchor stores, Fortunoff and Circuit City, shuttered, further harming the prospects of the mall's survival. Even McDonald's left the food court around that time. These departures set off a vicious domino effect: the fewer stores, the fewer people would come to shop, which would lead to more stores closing, and fewer shoppers.

Within a few years there were just two eateries in the food court … and then one … and then none. Soon the mall was mostly empty. The remaining stores dropped

out one by one, like a chilling retail version of Agatha Christie's mystery novel, *And Then There Were None*. A handful of stores remained as of 2017, and by 2018, it was down to just a pet adoption center on the second floor, once a sea of wildly varied vendors. In a surprising turn, the Fortunoff name was resurrected with the Backyard Store on the ground floor. Though customers continued to come for the Cheesecake Factory and PF Chang's, for several years, the rest of the mall was a dead zone, with long, hauntingly empty corridors of shuttered stores.

The mall went into foreclosure in 2012, but an auction of the property found no buyers to assume the $148 million in debt, so creditors took over. For a time in 2014 and 2015, there was speculation that the mall could become a casino, but that plan did not go forward due to community opposition. By 2016, the mall was potentially slated to be demolished. Finally, in 2017, Lesso Mall Development Long Island Inc. (a subsidiary of a Chinese company) bought the mall for $92 million and originally intended to reopen it as a mall of home improvement showrooms called Lesso Home New York in 2018, but the project was delayed.

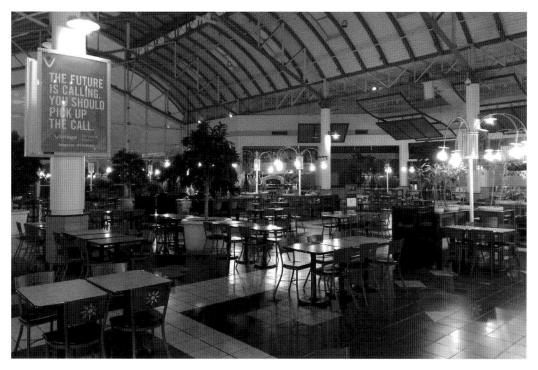

The once thriving food court completely empty, as seen in 2017. Once the McDonald's closed, it was a sure sign that things were going south.

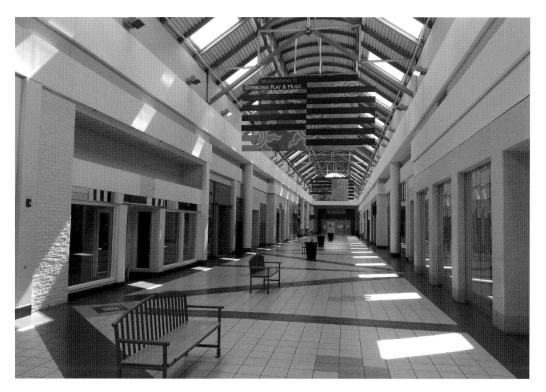

A long corridor of nothing was once filled with stores and shoppers.

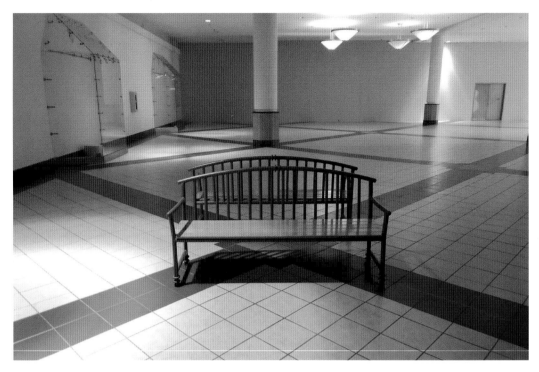

A forlorn bench on the ground floor of the mall. The newness of everything in this dead mall makes the scene even more eerie.

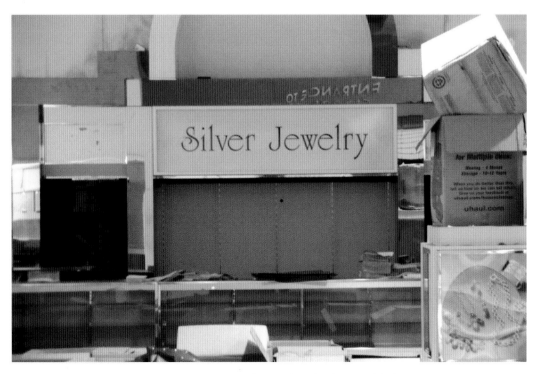

Looking into this empty space, it's hard to believe that Fortunoff used to be one of the New York area's most respected and popular department stores.

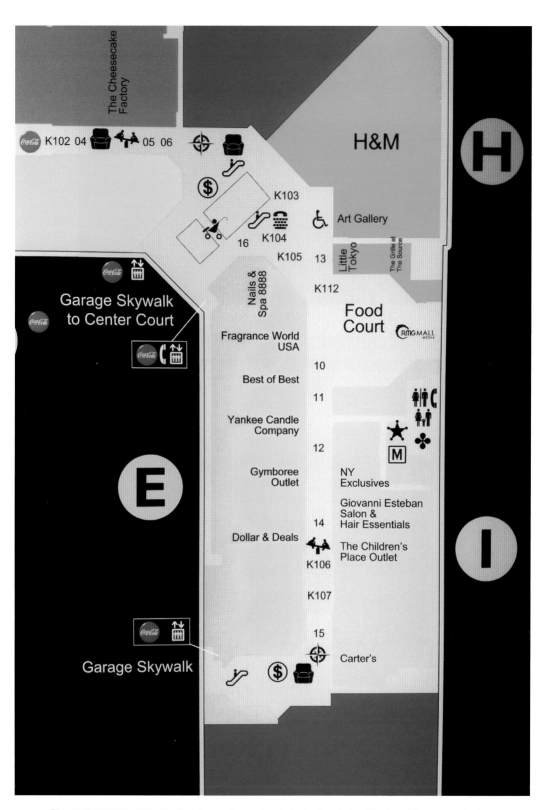

This mall directory dates to when the mall was already in decline, but well before it became a ghost town.

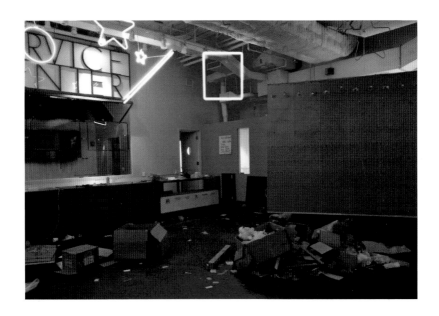

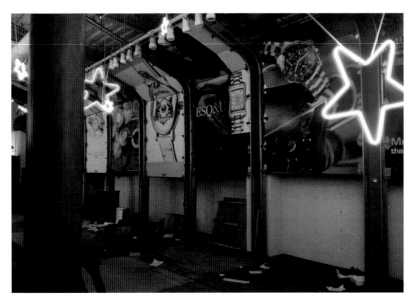

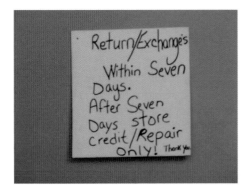

Top: Garbage and debris litters the floor of a former retail service center.

Middle: Watch advertisements line the wall of this ground floor space which, for some reason, still features lit decorations.

Left: A handwritten customer service sign still graces the wall.